	2	

COLORS

Other Books in the Series:

Red by Valentina Zucchi and Paolo D'Altan
Blue by Valentina Zucchi and Viola Niccolai
White by Valentina Zucchi and Francesca Zoboli
Black by Valentina Zucchi and Francesca Zoboli
Yellow by Valentina Zucchi and Sylvie Bello
Green by Valentina Zucchi and Angela Leon

COLORS

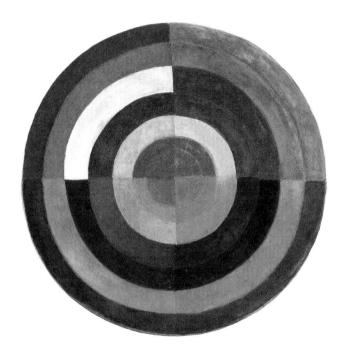

BY GIOVANNA RANALDI

Translated from the Italian by Katherine Gregor

CONTENTS

Exploring Color	7	
Color Wheels	8	
Splitting White Light into Color	10	
Complementary Colors	12	
Warm and Cool Colors	15	
Contrasting Colors	20	
Painting with Primary Colors – Yellow, Red, and Blue	23	
Interaction Between Colors and Optical Effects	26	
Color to Represent the Invisible	28	
Simultaneous View of Colors	32	
Simultaneous Color Workshop	35	
Tones	39	
Color Names	42	
Manufacturing Color	47	
The Color of Light	51	
Color and Shape	54	
Color and Emotion	56	
The Color of Dreams	59	
About the Artists	61	

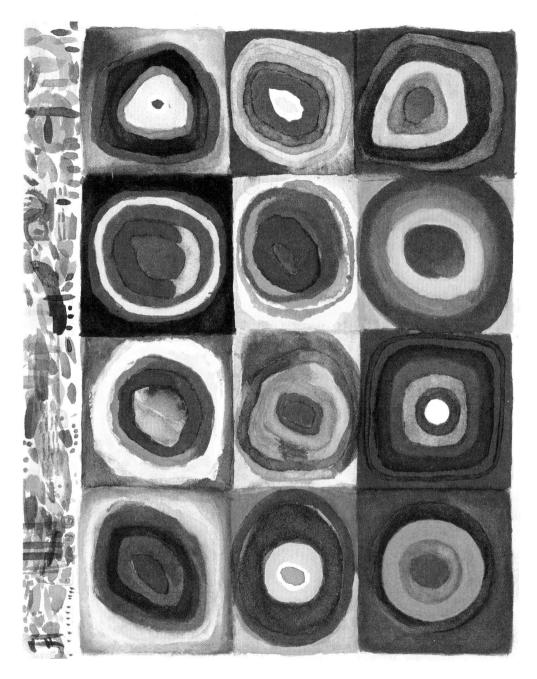

Wassily Kandinsky's Squares with Concentric Circles, 1913, Städische Galerie, Monaco

EXPLORING COLOR

This award-winning study of color in art is based on the original Italian edition by Giovanna Ranaldi. It is designed with a view to helping its readers expand their knowledge of painting with color by investigating its use in a range of modern works of art. The examples in this book are all images of original works by the finest exponents in the use of color at the height of their powers. It is through them that the reader can get in touch with the world of color and use it to explore their own creativity.

Basing the investigations on actual works of art not only results in active learning, it encourages further research and investigation which can only lead to more in-depth understanding. A Google search will quickly reveal a treasure trove of image archives and historical research, which will entice the reader to find out more and to seek out the galleries and museums they are able to visit to see such works in the original.

Each section examines a particular aspect of color, starting with the color wheel. Giovanna invites readers to learn about the origins of color, the relationships between them and our visual and psychological responses to them. Through this focus, budding artists can use the exercises following each section to learn to observe color, to consider it and to use it with different techniques and materials.

With this approach, the author throws open the door to a world of opportunities, an active learning technique that inspires confidence and experimentation.

Throughout the book, you will find spaces to extend drawings, try out suggested exercises, make your own sketches or notes, and write your impressions about what you see, notice and think. Make sure you always have a notebook with you so you never lose a creative idea or impression.

COLOR WHEELS

Artists of all ages - from young children upwards - have always enjoyed arranging colors, from the lightest to the darkest, from one shade to another. For centuries, philosophers, theorists, physicists, scientists and artists have all been doing the same thing in countless different ways in order to discover the secret of color. After many attempts, they finally settled on the color wheel as the most effective way of creating an orderly range of colors.

The scientific theories regarding color were preceded by the empirical knowledge of painters who, relying only on their experience, applied intuitively the principles eventually defined by scientists.

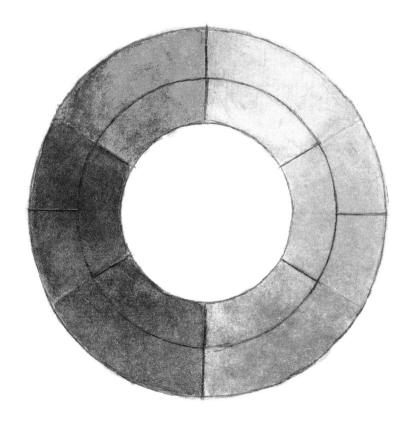

Johann Wolfgang Goethe, Color Wheel in Theory of Colors, 1810

Isaac Newton was the first physicist to explain the nature of color according to the rules of science. Three hundred or so years ago, by means of a revolutionary experiment, he discovered and proved that sunlight is the sum of all the colors in the spectrum. Newton pointed a beam of white light at a prism and discovered that the white light split into seven colors – the colors of the rainbow: red, orange, yellow, green, blue, indigo and violet. When the newly formed color beams went through a second prism, they once again became white light. With two prisms, you can replicate this experiment. What happened led Newton to the conclusion that white light is made up of all the colors of the spectrum put together and that color is not a characteristic of objects but of light itself.

Newton's experiment also clearly demonstrates why we see objects in different colors. Light reaches our eyes after encountering and passing through matter. Whenever white light – whether sunlight or that emitted by a bulb or other light source – hits objects, some surfaces absorb the light waves while others reflect them. Leaves, for example, are green because they diffuse green waves and absorb all the others. An apple will look red to us because it will diffuse the red waves and absorb all the others. A white object reflects all the colors; a black object, on the contrary, absorbs them

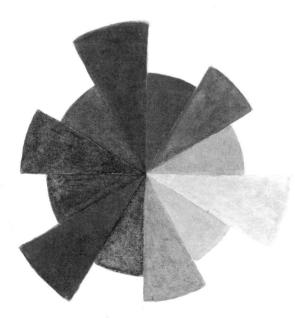

Paul Klee, *Color Wheel*, drawing from the notebooks used for lectures at the Bauhaus, 1921-1931.

SPLITTING WHITE LIGHT INTO COLOR

Cut out a circle of white card of approximately 5 inches in diameter and divide it into six equal segments. Color in each segment in the following order: red, orange, yellow, green, blue, and violet. Pierce two small holes in the center and thread a circle of string through the holes. Spin the string, then release it to make the circle spin as quickly as you possible.

As you watch, the circle will turn white. This demonstrates that white light contains all the colors of the spectrum in the same way as splitting it with a pendulum.

Another demonstration of splitting white light is the formation of a rainbow

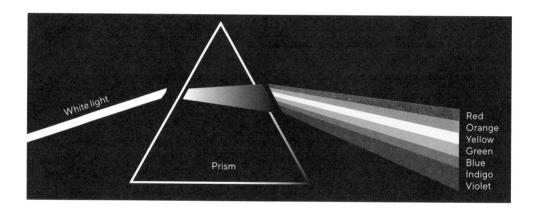

Rainbow Sky

Next time you see a rainbow, see if you can capture the subtle change of the colors. Use any medium to reproduce it below.

COMPLEMENTARY COLORS

Complementary colors are the ones that appear opposite one another on the color wheel. You can create a wheel that demonstrates the complementary colors by starting with the primary colors and mixing the pairs together to establish the color that comes between them on the circle.

When you look at a painting in a museum, on the internet or in a book, see if the painter has combined complementary colors. You'll discover that painters often use colors in very clever ways.

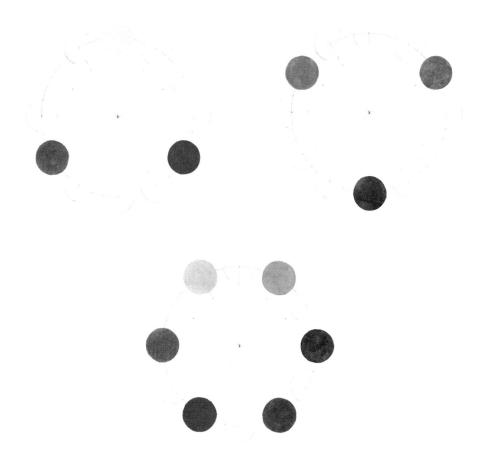

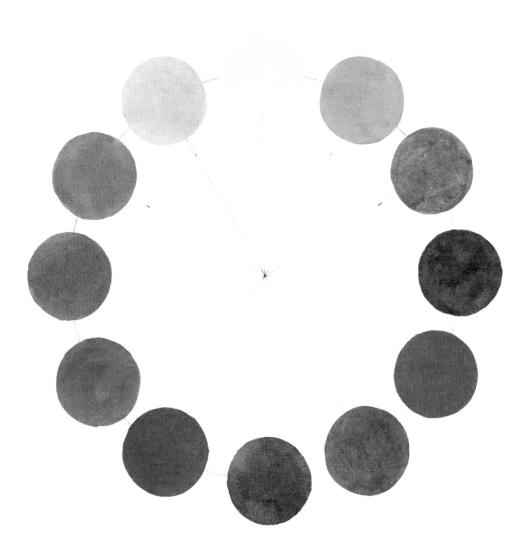

Try producing your own color wheel in the framework below.

Start with the primary colors: red, yellow, and blue.

Mix them to make the secondary colors: orange (red + yellow), green (yellow + blue), and violet (blue + red).

Mix adjacent colors to create the tertiary colors: orange-yellow (orange + yellow), yellow-green (yellow + green), green-blue (green + blue), blue-violet (blue + violet), violet-red (violet + red), and red-orange (red + orange).

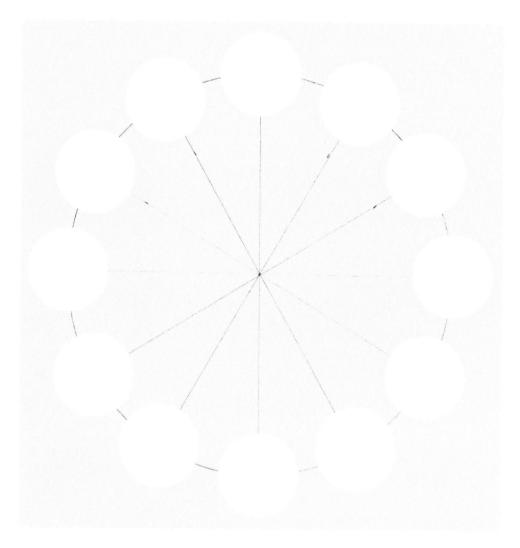

WARM AND COOL COLORS

Colors can be subdivided into warm and cool colors. There are several ways to tell which group they belong to by thinking about how they relate to primary colors and by relying on the sensations they convey.

Those that veer towards red, yellow, and orange are the so-called warm colors because they make you think of the warmth of the fire and the sun. These are yellow, orange-yellow, orange, orange-red, red, and violet-red.

Those that make you think about the cold, the dark or the night, on the other hand, are called cool colors. These are shades of blue, green, and grey: green-yellow, green, blue-green, blue, violet-blue, and violet.

You can also tell warm and cool colors apart for "psychological" reasons: you could say that warm colors arouse feelings connected with happiness, liveliness, and energy whereas cool colors induce states of mind that are more melancholy, thoughtful, calm, and meditative.

Another difference is in the depth they communicate: warm colors seem to come forward while cool ones seem to step back.

Experimenting with Warm and Cool Colors

Make two drawings of a room in your house using color pencils. Do the first using only warm colors, then the second with cool colors. Compare the effects and the atmosphere you have created in each drawing.

Try the same experiment with a view of your garden or an outside space.

CONTRASTING COLORS

We could say that there is no such thing as an absolute color, or rather that it only exists for as long as it's enclosed in a tube. Our perception of a color always depends on the color next to it.

In the 19th century, the chemist Michel Eugène Chevreul, an expert in dyes, studied the principles that govern color contrasts. He discovered that the intensity and power of colors depends more on the influence of neighbouring colors than on pigmentation.

As far back as the 15th century, however, painters already aware of the importance of contrast. For example, Leon Battista Alberti wrote that, "The color red, if placed between blue and green, becomes quite important ..." By that he meant that it becomes brighter and more intense.

Claude Monet, one of the most famous Impressionist painters, wrote that, "Color owes its intensity more to the strength of the contrast than to its intrinsic qualities ... Primary colors seem brighter when they are contrasted with their complementary colors".

While Vincent Van Gogh said, "There is no blue without yellow or without orange".

Identifying Colors and Color Contrasts

Practice identifying primary and secondary colors. See how each one of them changes depending on the colors next to it and make notes on the impact of one color on another.

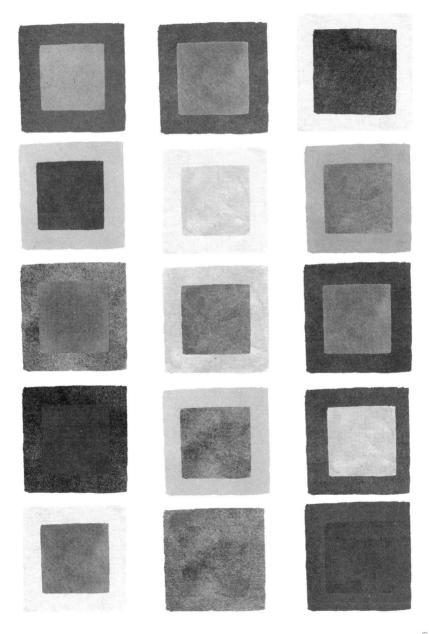

Create Your Own Color Squares

Try painting your own color squares using a range of contrasting and complementary colors.

PAINTING WITH PRIMARY COLORS - YELLOW, RED, AND BLUE

In the 20th century, while scientists and philosophers continued their research into how our eyes see, painters studied new ways of thinking about shapes and colors, as well as their connections and their sheer beauty. This signalled the birth of abstract art.

In 1920, Piet Mondrian, who had been studying color for a long time, produced a series of paintings characterized by vertical and horizontal lines that formed a grid. He colored in the spaces using only the primary colors – red, blue, and yellow – using black for the lines and white for the background. It was his way of representing rhythm, the universe, harmony, and perfect balance.

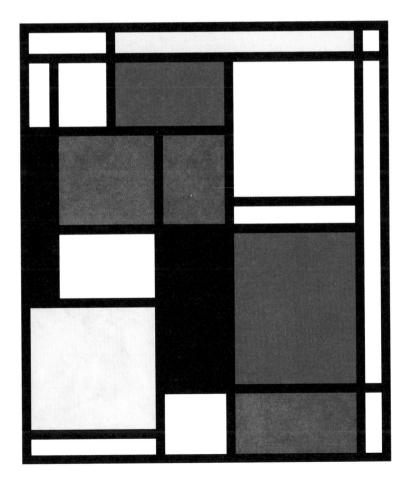

Piet Mondrian, Tableau No.2 with Red, Blue, Black and Grey, 1922, Guggenheim, New York

Experimenting in the Style of Mondrian

Try to create a composition in the style of Mondrian using the same colors as the artist.

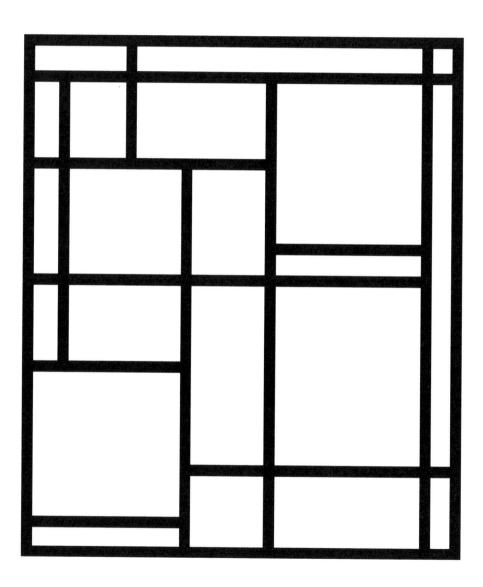

Now do a second experiment using colors of your choice.

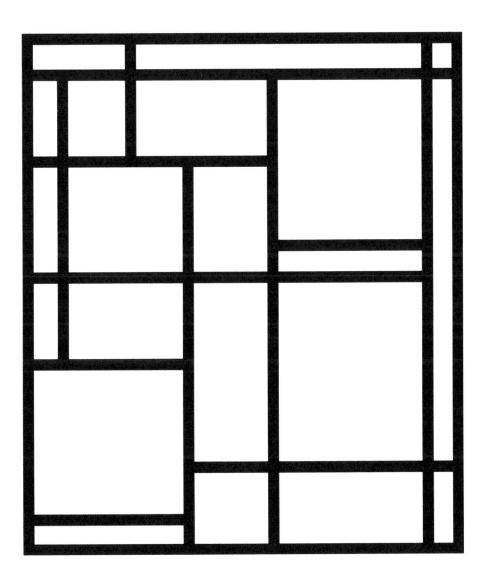

INTERACTION BETWEEN COLORS AND OPTICAL EFFECTS

Josef Albers was a primary school teacher but also painter, a designer, a scholar and one of the founders of a great movement of artists, the Bauhaus, which, in the 20th century, completely changed our way of seeing, designing and building objects, spaces and houses. His research into colors deeply influenced our way of seeing and working. Albers studied how shape, size, distance and contrast influence our perception of color; in other words how context determines our way of seeing things. His most famous work on the subject was *The Interaction of Color*, published in 1963.

Albers' book was designed as a teaching resource for artists. It explored his theory of color and how we perceive it in different ways, and explained the principles behind the theory and effective methods of teaching the concepts.

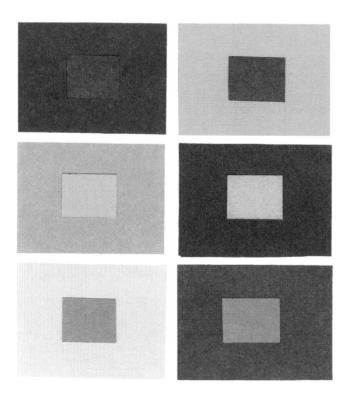

Discovering Color Interaction

Following Josef Albers' example, draw and color in at least six large rectangles of card, then cut them out. You could start with the primary colors, then the secondary and finally the tertiary. Then draw, color and cut out the same number of slightly smaller cards.

Lay out the larger cards, then place the smaller ones on the top. You might want to work with one foreground color at a time. Look at how the same color changes when it is placed on top of cards of different colors. Make notes on what happens, or draw your conclusions visually.

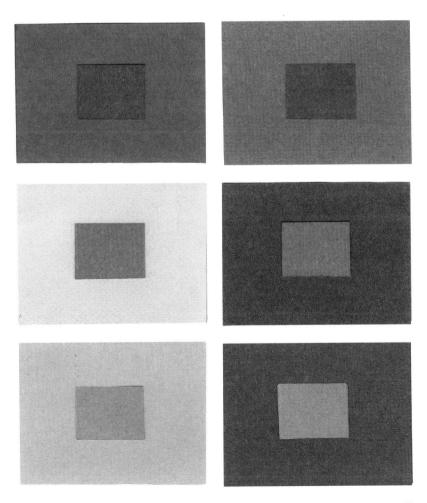

COLOR TO REPRESENT THE INVISIBLE

The Russian painter Wassily Kandinsky was one of the founders of abstract art. Color for him had two effects on humans: a superficial 'physical effect' based on an immediate sensation, and a 'psychic effect' caused by the internal vibration it arouses in a person and which touches the soul. For Kandinsky, art actually has a spiritual dimension.

According to Kandinsky, every color has a smell, a taste, a sound, a shape and specific emotional properties. Yellow, for example, conveys excitement, passion and sounds like a trumpet. Orange is energy and sounds like a bell. Dark blue is dramatic and sounds like an organ; pale blue is calm, and sounds like a flute.

Kandinsky made a number of color studies, always using very bright and strong colors, to explore the impact of colors in relation to others.

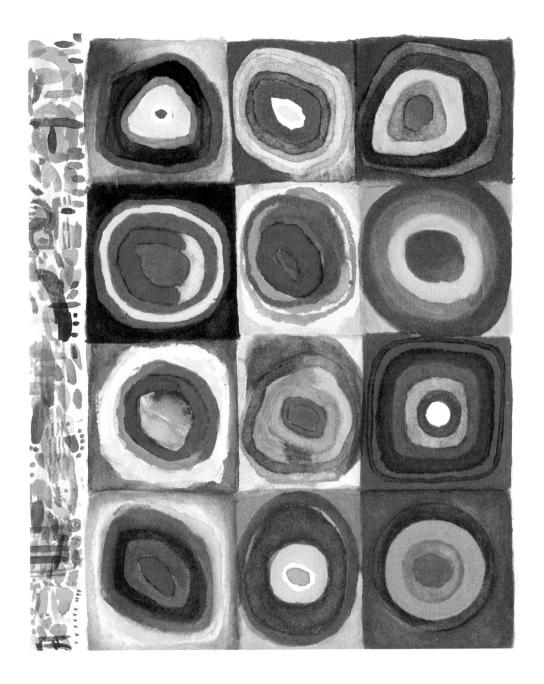

Wassily Kandinsky's Squares with Concentric Circles, 1913, Städische Galerie, Monaco

Creating Your Own Color Study

Following Kandinsky's studies on color, use whichever technique you prefer for this exercise: watercolors, felt-tip pens, pencils or crayons. Paint a surface made up of squares with concentric circles inside them. Choose the colors you think go well together based on how they make you feel.

Color Correspondences

Kandinsky devized a questionnaire of 28 questions designed to test his theory of color with his students. Try illustrating these suggestions with the most appropriate colors for you.

A circle

A square

A triangle

The song of a canary

The mooing of a cow

The sound of the wind in the trees

Talent

Excitement

Sadness

A storm

A sunny day

A snowy day

SIMULTANEOUS VIEW OF COLORS

The painter Robert Delaunay also spent a long time studying colors and light. His first completely abstract work is his First Simultaneous Disc, painted between 1913 and 1914. In this painting, Delaunay experimented with alternating colors, so that the onlooker could see more colors next to one another simultaneously. It also captures variations in brightness and composition according to scientific laws of perception.

His arrangement of color was inspired by the theories of Michel Eugène Chevreul, the chemist we've already mentioned, who was the first to use the expression "simultaneous contrast" when he realized that the simultaneous perception of two colors increases the depth of the color.

During the summer of 1913, Delaunay and his wife Sonia experimented with sensations connected to colors by looking directly at sunlight and then trying to capture on canvas the images that left an impression after they closed their eyes. Do not copy this experiment; it is dangerous to look directly at the sun.

Devising a Color Disc

Look carefully at Robert Delaunay's disc. The round canvas is divided into concentric circles, each in turn subdivided into four segments. Copy it, color it in and try to give a name to all the colors that make it up.

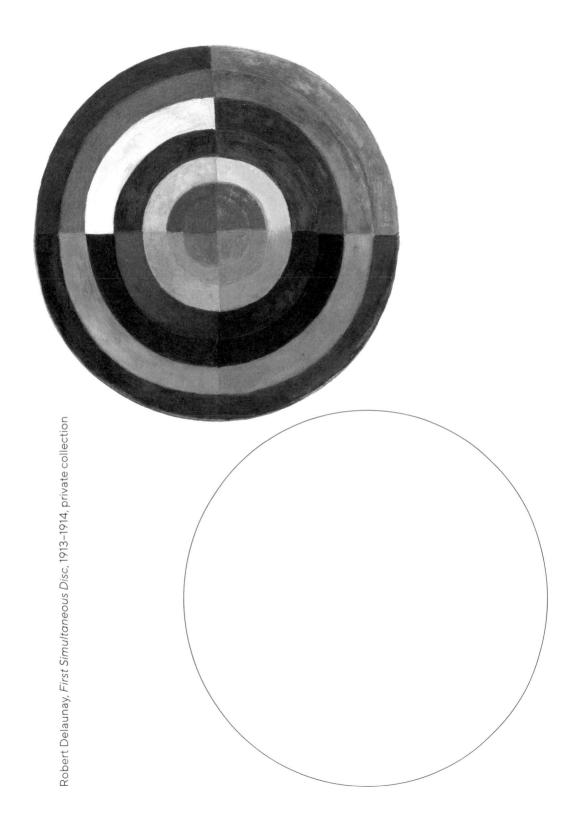

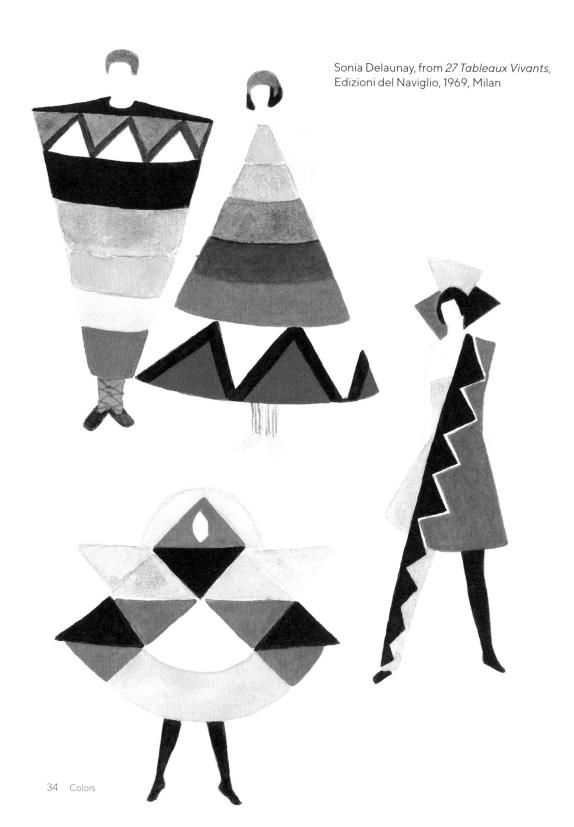

SIMULTANEOUS COLOR WORKSHOP

Like her husband Robert, Sonia Delaunay was also a versatile artist who devoted herself to experiments with colors and shapes which she used in her paintings.

She also applied the principles to other fields, such as fashion and the theatre. In her studio, called "Simultaneous Lab", she created the first simultaneousstyle fashion: dresses, scarves, handbags, hats. The clothes and accessories had geometrical patterns and colors based on the optical law of simultaneous contrast achieved, in particular, by placing the complementary colors next to each other. The result was her splendid clothes, that seemed made of color, light and rhythm.

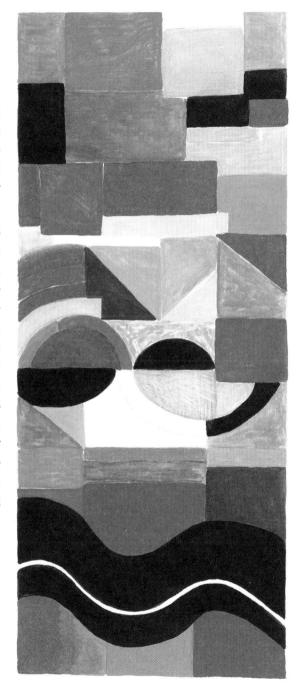

Sonia Delaunay, Syncopated Rhythm or The Black Snake, 1967, Musée des Beaux-Arts, Nantes

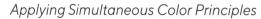

Look at these illustrations by Sonia Delaunay, from 27 Tableaux Vivants (Edizioni del Naviglio, 1969, Milan). Use the space to draw a costume for an imaginary stage character, using geometrical forms and complementary contrasts such as red and green (which comes from mixing blue and yellow) or blue and orange (which comes from blending red and yellow).

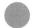

You may want to extend this exercise and create the costumes for all the characters in a play – real or of your own invention.

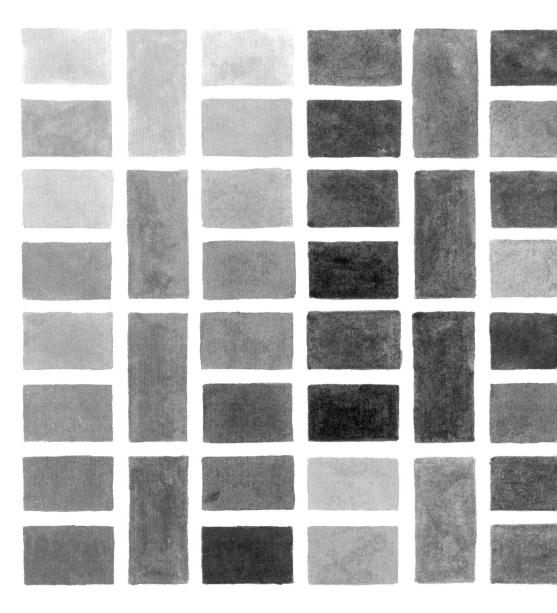

A. Boogert, Traité des Couleurs Servant à la Peinture à l'Eau, 1692

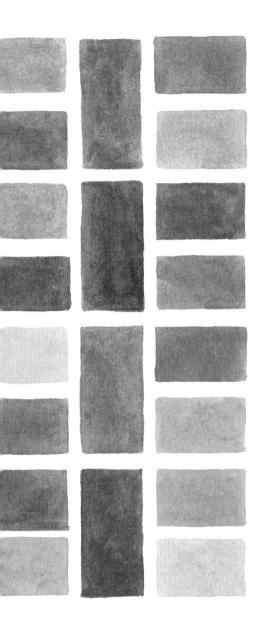

TONES

In 1692, Dutchman, A. Boogert, wrote and hand-painted a wonderful treatise on color: *Traité des Couleurs Servant à la Peinture à l'Eau*. The book has over 800 pages demonstrating to aspiring painters how to make up, mix and change the tone of colors by adding 'one, two or three portions of water'.

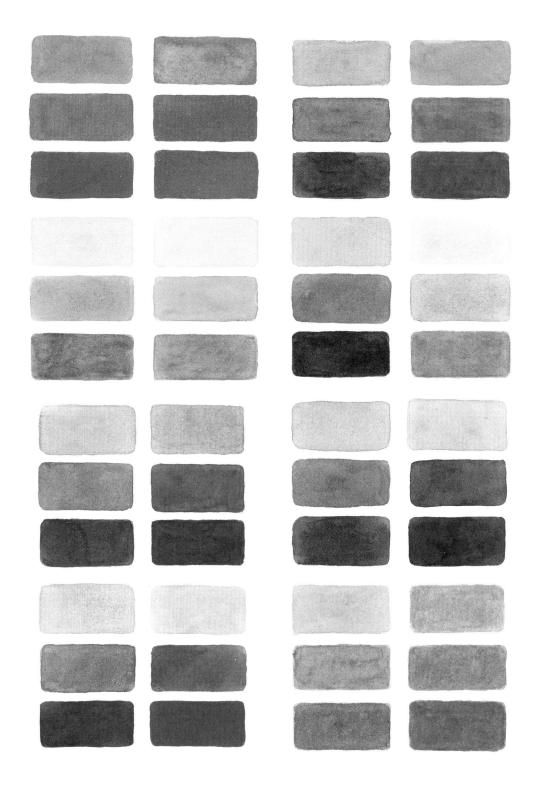

Creating Color Tones

Practice controlling the nuances of color with watercolor paints. Use one color palette at a time and make a rectangle of that color, then paint adjacent rectangles adding one, two and finally three portions of water.

COLOR NAMES

Colors have beautiful names that often reveal their origins: for example, if they are made from vegetable or animal matter (organic colors) or mineral matter (inorganic colors). Inorganic colors are the more modern ones. chemically produced in laboratories and factories. For painters, the more stable a pigment - or the substance of the color - the better; in other words it should be as resistant as possible to temperature and light. Here is a list of interesting colors.

INDIAN YELLOW

In the past, this was obtained from the urine of cows fed on mango leaves. However, in 1890, it was outlawed in Bengal following the discovery that mango leaves were harmful to cows. What is currently sold is chemically produced.

CHROME YELLOW

This vibrant color is the yellow that was so frequently used by Van Gogh. It was first obtained in the early 1800s and was one of the new pigments which, thanks to chemistry, became available to painters and altered the impact that could be achieved. It is rather toxic, however, which is why nowadays it is often replaced with cadmium yellow.

SAFFRON YELLOW

"Yellow is a color made from a spice called saffron", wrote 15thcentury Tuscan painter Cennino Cennini in his manual on painting techniques. Produced with the pistils of the flower Crocus sativa, it's a yellow that was mainly used in miniatures.

SAP GREEN

This color was obtained from the berries of the buckthorn shrub. A concentrated solution of Arabic gum (a resin produced by false acacia) would be added to the berry extract. Once prepared, the product was stored in pig's bladders.

GREEN EARTH

Some of the oldest pigments, used since prehistoric times, are "earths" that were actually produced with earth. In Italy, green earth is also called Verona earth because it originated in that northern Italian city. It was often used in frescoes and tempera painting, especially as a base over which the pink of faces was painted.

FMERALD GREEN

This is named after its vibrant shade that reminds us of the gemstone. It was created between the late 18th and early 19th centuries. It's a synthetic color, in other words chemically obtained.

Color Development

Now that you have read about these colors and their history, invent a yellow color of your own, give it a name, then write about its origin and how it is used.

DRAGON'S BLOOD

This is a deep red varnish that has been used since antiquity. Legend has it that during a fight between a dragon and an elephant, the blood of the two animals was mixed and the result was called "dragon's blood". In actual fact, it is extracted from the trunk of a plant, the Dracaena draco.

CINNABAR OR VERMILION

Another ancient color, cinnabar is a very bright red which came from grinding the mineral of the same name. The word "vermilion" derives from the Latin vermiculus, a diminutive of vermis, or worm. In Latin, the word referred to the cochineal, Kermes vermilio, the insect from which the color was obtained.

TYRIAN PURPLE

Known since antiquity, it was obtained from Mediterranean gastropods (mainly Murex brandaris). Very expensive, it used to be used by the rich for dyeing cloth and was the color of the togas of Roman senators

Color Development

Try reproducing the tones of red and purple above and make notes on how you did so.

ULTRAMARINE

It is called that because it came from the Far East, in particular from Badakshan, present-day Afghanistan. During his journey to China in 1271, Marco Polo wrote about a mineral from which a dark blue pigment was extracted. Obtained by grinding lapis lazuli, a semi-precious stone, it was very expensive. The Dutch painter Vermeer, who used only the finest materials, got into debt in order to acquire it.

EGYPTIAN BLUE

The color of those splendid Egyptian blue scarabs, hippopotami, cats, necklaces, vases and bottles you see in museums, this color has been used since the Fourth Dynasty of Egypt (2600 BCE). It's the first true synthetic pigment among the ancient colors, obtained by heating a mixture of limestone and copper at very high temperatures with a substance that helped them melt.

ORGANIC INDIGO

It is one of the oldest known dyes, and is used in particular for dyeing fabrics. Mummies wrapped in linen cloth dyed with indigo have been discovered in Egypt. Nowadays, it is best known as the classic color of jeans. It is produced by grinding the leaves of *Indigofera tinctoria*, letting them ferment and then adding ash (potash) in order to obtain different shades. To protect themselves from the sun, the Tuaregs and other North African peoples dye their clothes and skin with indigo powder, which is why they have been called "blue people".

SIFNNA

Known since antiquity, the name derives from a kind of colored soil extracted from quarries in the Sienna region. In his 1568 book, *The Lives of the Most Excellent Painters, Sculptors, and Architects*, the painter Giorgio Vasari calls it terra rossa (red soil). You can see it in many medieval and Renaissance churches and *palazzi* in Tuscany.

BURNT SIENNA

In order to obtain a warmer shade, sienna is spread on a metal sheet then exposed to a source of heat. The intensity of the heat changes the shade of the soil.

UMBER

This is also colored soil. Its name possibly comes from an ancient quarry near Spoleto, in Umbria, or perhaps because it was very well suited for painting shadows (in Italian, shadow is ombra).

IRON GALL INK

This color is obtained from the galls, growths that form on the branches of Quercus infectoria after an insect, the gall wasp, lays eggs in the bark. The galls are pulverised and boiled together with ferrous sulphate and Arabic gum. This is a very ancient recipe used ever since the Ancient Greeks and even nowadays. Leonardo da Vinci also used this ink to draw with and Bach wrote. his compositions with it.

BONE CHAR

This is a charcoal obtained from charring animal bones, then pulverising them. Known since antiquity, it has been mainly used in oil painting. Bone char can have warm yellow or brown tones, unlike carbon black, which tends to be cooler blues and violets.

Color Development

These tones are associated with the earth. Develop some of your own earth colors

MANUFACTURING COLOR

Human beings have been manufacturing colors since the dawn of time. The first color production dates back about 70,000 years. It can be found in the Blombos Cave in South Africa, where stone pestles have been discovered, which were used for pulverising rocks and soil, as well as a few abalone shells that served as containers for colors.

About 18,000 years ago, the walls of the Lascaux Caves in France and the Altamira Caves in Spain were covered in splendid graffiti and paintings in ochre, red, and black.

Ancient Egyptians, Greeks and Romans also had designated factories for manufacturing color. In the excavations of Pompeii (the city that was destroyed in an eruption of Vesuvius in 79 AD), the archaeologists

Cave paintings in Altamira, Spain

discovered art shops selling a catalogue of colors that are now exhibited at the archaeological museum in Pompeii.

In artists' workshops, colors were ground by hand from stones and colored soil until they turned to powder. These powders, called pigments, were then diluted and mixed with various binders depending on the kind of color you wanted: watercolor, tempera and, starting from the first half of the 15th century, also oils.

The paints were stored in shells, ceramic or glass jars, or else casings made from pig's bladders.

Many colors eventually used in painting were created for dyeing wool, silk, cotton and linen. Italy, and Tuscany in particular, distinguished itself in the art of dyeing from the 13th century. The magnificence of Tuscan fabrics was famous throughout Europe. In Florence, in the city center, there is still a street called Corso dei Tintori (tintore in Italian is a dyer).

In the 16th century, thanks to trade between East and West, the range of colors increased and their manufacture became more varied and refined. Venice, the main trading center at the time, made it feasible for artists to obtain every possible and imaginable pigment.

In 1704, the first synthetic color came about by accident: it was the Prussian blue pigment.

The greatest change, however, occurred during the 19th century, when chemistry and industry developed. New shades were created that were often brighter and deeper than natural colors, which were gradually replaced by synthetically produced materials.

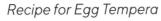

Try making your own egg tempera and create your own cave paintings below.

1 egg yolk2 teaspoons raw linseed oil1 tablespoon white vinegar6-8 small teaspoons waterOchre powder purchased from an art shop

Put the egg yolk, linseed oil, vinegar and water into a small bottle; close tightly and shake hard, so that all the ingredients blend well. Put a small amount of ochre into a bowl and add the tempera using a dropper. Mix the paint with a palette knife or a teaspoon until you obtain a creamy substance. You can use this paint on paper or canvas. You must shake the bottle every time you make this color.

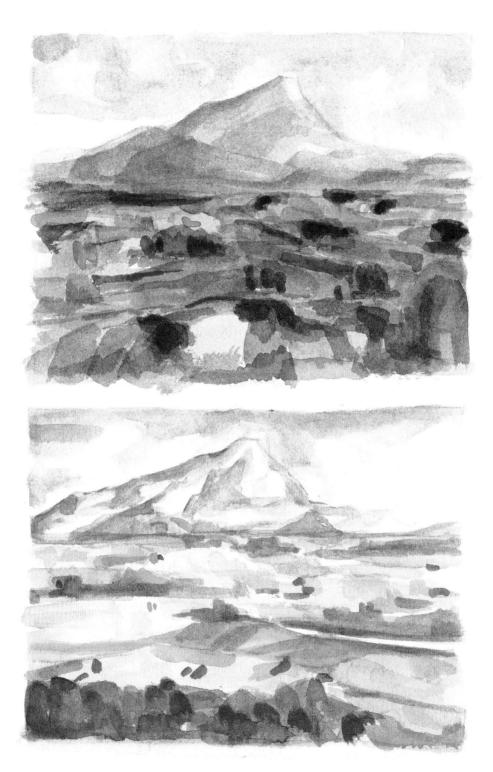

Paul Cézanne, The Mountains of Sainte Victoire, 1904-1906, Zurich Art Gallery

THE COLOR OF LIGHT

Paul Cézanne wrote that "Light cannot be reproduced but must be represented through color. I was pleased with myself when I discovered this". Cézanne liked to paint outdoors and often the same landscape, like Mont Sainte-Victoire, which often recurs in his paintings. It's always the same scene but is rendered unique because the light that illuminates it is different every time.

Painters have been studying light and its color since ancient times. Leonardo da Vinci, for example, observed that air alters the color and sharpness of objects: the further they are from your vantage point, the more shrouded in blue they appear.

Centuries apart, painters therefore noticed how the shade of the light influences our way of seeing and how it can be conveyed through painting. On a rainy day, the light will be cooler, so everything we see will be influenced by that kind of light. If you want to paint a landscape on a rainy day, it's not enough to color the sky grey; you must also see how the light changes the tone of everything you see and want to paint.

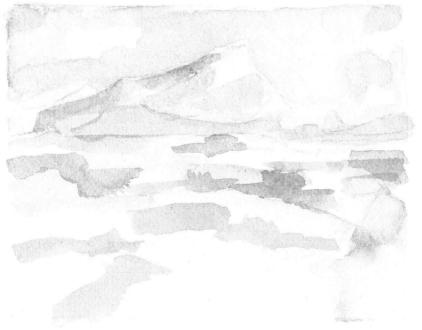

How Light Affects the Landscape

Through the same window, observe the landscape at different times of the day, in different weather conditions and in different seasons. Using words and drawings, jot down how light influences the colors of everything you see.

COLOR AND SHAPE

"Whenever you go out to paint, you must strive to forget about the objects you have before you: a tree, a house, a field or whatever else. Just think: here's a little square of blue, here an oval of pink, here a strip of yellow; then paint exactly as the color and shape appear to you until you obtain your impression of the scene before you".

These are the words of Claude Monet, an Impressionist painter who worked mainly outdoors, as he tried to represent reality through his impression of it. Monet writes about how he observes and paints, focusing on colors, shapes and lines, to convey his perception of what he saw rather than actual reality, and he urged his students to do the same. At the time, this was revolutionary advice because the exact opposite was being taught in painting academies.

The ideas of the Impressionists were also based on new information and theories of color and were achieved thanks to new colors that were available to buy, which were so bright that they made it possible to convey intensely the effects of the light.

Look at a landscape and paint it, trying to find the shape and color of what you see, forgetting what it actually is. For example, if you paint a tree, forget it's a tree; try instead to see and paint only the colored shapes that make up its form.

COLOR AND EMOTION

The painter Henri Matisse was in love with color and devoted many reflections to it, including this one: "You are increasingly conquered by colors. A particular blue penetrates your soul, a particular red affects blood pressure, a particular color is invigorating. It's the concentration of tones".

He also wrote: "... color exists in itself and possesses its own special beauty ... I realized that you could work with colors that are expressive without necessarily being descriptive".

And finally: "I am simply trying to find a color that matches my feelings".

In the Middle Ages, painters knew that the colors available to them could not represent fully the variety and magnificence of nature. From the 19th century onwards, the new colors available for sale freed artists from such feelings of limitation. That was when some painters began to feel that their task was no longer that of representing nature faithfully, and that they could use colors to express emotions, feelings and sensations.

For Matisse, for example, color in painting did not necessarily need to correspond to that of real things but could be personal and subjective and express the sensations felt by the artist faced with whatever it is he or she is reproducing.

Henri Matisse, *Pictures of Lydia Delectorskaya*, 1947, Hermitage Museum, St Petersberg

Draw a self-portrait. Make several copies of it and color each one in a different way, following the example of Matisse.

THE COLOR OF DREAMS

The poet Jacques Prévert described Joan Miró, one of the most famous Surrealist painters of the 20th century, as "an innocent with a smile on his lips, strolling across his dream garden". Another writer friend of his, Raymond Queneau, said that his painting was like a new alphabet, the "miró", which they had to learn if they wanted to "read his poetry", in other words his works of art.

ce ci est la couleur de mes reves

Joan Miró, *This is the colour of my dreams*, 1925, The Pierre and Maria-Gaetana Matisse Collection

Painting Your Dreams

You, too, try to imagine with colors and shapes a new alphabet with which to draw your dreams.

ABOUT THE ARTISTS

There is a wealth of information on the internet, in museums and libraries. Use this information as a springboard for your creative exploration of the fascinating world of color.

Josef Albers (1888–1976) German artist and educator whose work, *The Interaction of color* in 1963 formed the basis of many 20th-century education programs.

Leon Battista Alberti (1404-1472) Italian philosopher and artist, the principal instigator of Renaissance art theory.

Johann Sebastian Bach (1685–1750) German composer and musician.

A. Boogert (1774-1885) Dutchman who in 1692 published an 800-page comprehensive guide to mixing watercolors: *Traité des Couleurs Servant* à la Peinture à l'Equ.

Cennino Cennini (c1370-1440) Tuscan painter who published *The craftsman's handbook*, a manual on painting techniques.

Paul Cézanne (1839–1906) Post-Impressionist painter at the forefront of the development of Cubism.

Michel Eugène Chevreal (1786–1889) French chemist and author of *The Law of Simultaneous Color Contrast*, first published in 1839.

Robert Delaunay (1885–1941) French abstract artist who spent a long time studying colors and light.

Sonia Delaunay (1885-1979) French abstract artist and a key figure in the Parisian avant-guarde, and particularly interested in exploring the interaction between colors.

Johann Wolfgang Goethe (1739–1842) German author and influential literary icon and amateiur artist who published *The Theory of Colors*.

John Goffe Rand (1801–1873) American portrait painter who invented the first artist's paint tube.

Wassily Kandinsky (1866-1896) Russian painter who was fascinated by different color combinations.

Paul Klee (1879–1940) A Swiss-born German artist whose work explored Expressionism, Cubism and Surrealism.

Henri Matisse (1869-1954) French painter known for his expressive use of color.

Joan Miró (1893–1983) Catalan artist and sculptor who combined abstract art with fantasy.

Piet Mondrian (1872–1944) Pioneering Dutch artist whose style evolved towards simple geometric elements.

Claude Monet (1840–1926) French painter and one of the founders of the Impressionist movement, which aimed to capture the artist's immediate perceptions of nature.

Isaac Newton (1642-1727) Highly influential English mathematician and physicist who studied optics, among many other disciplines.

Camile Pissarro (1830–1903) A Danish painter (born in what is now the Virgin Islands) who worked mainly in France and is best known for his influence in Impressionist and the development of post-Impressionist painting.

Marco Polo (1254-1324) Italian merchant and explorer who was responsible for opening up the trade routes between China and Europe.

Jacques Prévert (1900–1977) French poet and screenwriter popular for his writings on daily life.

Raymond Queneau (1903-1976) French poet, editor, wit and critic who was an influential part of the creative scene.

Auguste Renoir (1841-1919) Leading French painter in the Impressionist movement.

Alfred Sisley (1839–1899) A British Impressionist painter, working mainly in France, who concentrated on landscapes and worked mainly in the open air.

Vincent Van Gogh (1853–1890) Dutch post-impressionst painter notable for his highly emotive use of color.

Giorgio Vasari (1511–1574) Italian painter and the first art historian, who published *The Lives of the Most Excellent Artists* in 1568.

Johannes Vermeer (1632–1675) Dutch painter who specialized in interior scenes of middle-class life.

Leonardo da Vinci (1452-1519) Artist, scholar and inventor, widely considered to be the finest painter of all time.

This English language edition Published in 2021 by OH!, an imprint of Welbeck Non-Fiction Limited, part of Welbeck Publishing Group 20 Mortimer Street London W1T 3JW English Translation by © Welbeck Non-Fiction Limited

First published by © Topipittori Milan in 2020 Original title: *Colori* www.topipittori.it

Disclaimer:

All trademarks, quotations, company names, registered names, products, characters, logos and catchphrases used or cited in this book are the property of their respective owners. This book is a publication of OH!, an imprint of Welbeck Publishing Group Limited, and has not been licensed, approved, sponsored, or endorsed by any person or entity.

All rights reserved. No part of this publication may be reproduced, stored in a retrieval system, or transmitted in any form or by any means (including electronic, mechanical, photocopying, recording, or otherwise) without prior written permission from the publisher.

Colors by Giovanna Ranaldi ISBN 978-1-80069-003-5

Text © Giovanna Ranaldi Translator: Katherine Gregor Editorial: Wendy Hobson Design: Nikki Ellis

Production: Rachel Burgess

A CIP catalogue record for this book is available from the British Library

Printed and bound in China by Leo Paper Products Ltd.

10 9 8 7 6 5 4 3 2 1

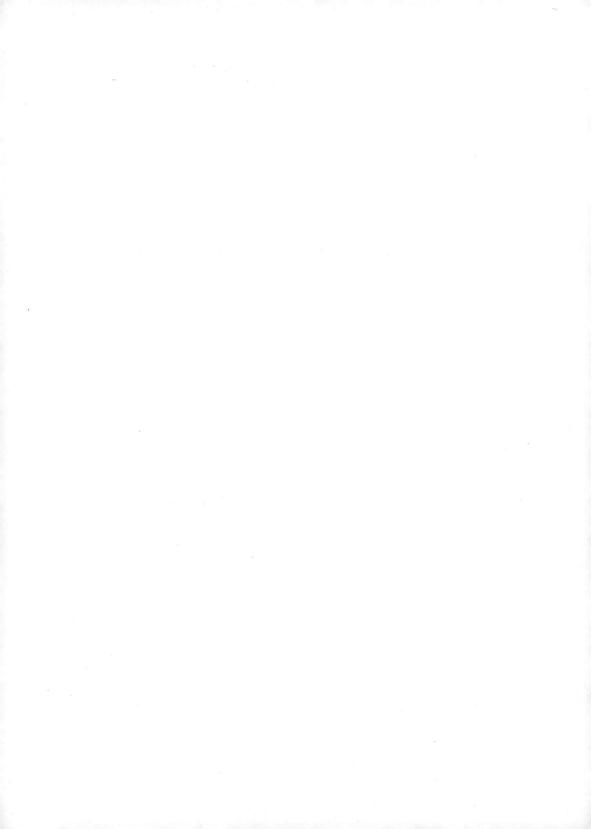